AGENCY QUOTES

VOLUME 2

by Nick Entwistle & Vikki Ross
#thingsyouhearinagencies

Copyright © 2017 Agency Quotes
All rights reserved. No part of this book may be reproduced, stored or transmitted, in any form or by any electronic or mechanical means, without permission in writing from the authors and publishers.

ISBN: 978-1-326-94590-9

"Run it by Legal"
No don't – it'll take ages to get signed off! We've made every effort to include all Twitter names for the tweets we've used, and we apologise for any unintentional mistakes.

This book is published on demand so we don't make a profit, which means we can't pay anyone whose quotes we've included.
Quotes were tweeted by the people we've credited, although they may have been quoting someone else.

"Who's responsible for this?"

Nick Entwistle
Nick is the Creative Director at film-based advertising house MAGNAFI, where he has created effective campaigns for big brands including the #LoveYourNHS campaign that helped the NHS beat Justin Bieber to Christmas Number 1. He also runs the award-winning One Minute Briefs social platform which brings together creatives across the world for daily online advertising briefs and networking events. As well as this, he delivers inspiring talks and workshops for the likes of D&AD, Glug and the BBC under the guise of his Bank of Creativity brand.

@BOC_ATM
@OneMinuteBriefs
interest@bankofcreativity.co.uk

Vikki Ross
As one of the UK's leading copywriters, Vikki has been writing for major brands for 20 years. She specialises in branding and tone of voice, tutors copywriting and runs workshops around the world on behalf of D&AD, SheSays & Creative Equals. Vikki also regularly chairs or sits on marketing and advertising industry award panels, and intent on celebrating copywriting, created #copywritersunite, the Twitter hashtag that connects copywriters globally, and Copy Cabana, an annual industry event.

@VikkiRossWrites
vikkirosswrites@mail.com

CONTENTS

7	**FOREWORD**
9	**CLIENTS**
21	**ACCOUNTS**
31	**MEETINGS**
39	**BRIEFS**
49	**PLANNING**
57	**STRATEGY**
65	**BRAND**
71	**GUIDELINES**
75	**STUDIO**
87	**BRAINSTORMS**
95	**PITCH**
101	**SHOOTS**
107	**COPY**
113	**DESIGN**
121	**LOGO**
129	**FONT**
135	**DEADLINES**
141	**TIMESHEETS**
145	**FEEDBACK**
155	**DATA**
159	**SOCIAL**
165	**DIGITAL**
171	**CHRISTMAS**

FOREWORD

"That's going on @AgencyQuotes"

It's funny the things you hear in agencies. Ad speak, technical jargon, client feedback. That's what we thought back in 2012 so we created @AgencyQuotes on Twitter – a place for everyone agency-side to celebrate the advertising industry together and tweet all the #thingsyouhearinagencies

Since then, we've shared 26,000 tweets to over 10,000 followers around the world, and released a book of some of the best quotes. This is our second book – even bigger than the first! You'll probably recognise a few. You'll definitely nod knowingly. You may even laugh. Just don't cry.

If you get involved on Twitter and share all the #thingsyouhearinagencies, then thank you. Our books are for you. If you've never heard of the hashtag and picked this book up by chance, then thank you too. We truly appreciate everyone's support and look forward to hearing more brilliant agency quotes in the future.

@AgencyQuotes

8.

CLIENTS

"They'll know what they want when they see it."

- @Cocktail_mktg

"I hear what you're saying, & I agree with you, but let's just give them what they've asked for."

- *@shhhem*

"The client don't get 'lorem ipsum'. They don't get it at all."

- *@lynnzieee*

> "Can we have it delivered by Tuesday?"
> "It is Tuesday."

- @DanMallerman

> "4:50 PM: We require creative for a campaign that is due to start tomorrow. Please advise when we will receive it."

- @Kurt_Runge

**"Client: We need a plan for a campaign of ours!"
Me: "Sure, so what's it about?"
Client: "Don't know yet, I'll tell you!"**

- *@granvilledsouza*

"The client wants the bird to come out of the product?!"

- *@CristinaReyna*

"The client really likes it, but they've decided to run it next year."

- *@Senanlee*

"Be bold, but don't take any risks with our brand"

- *@SimeonJRT*

"We're working towards being the top ranking in any form of donkey-related searches."

- *@kittyfondue*

"Ever get the feeling this client hasn't got a fucking clue?"

- @PeterJStephen

"We want our website to rank in the first three by next week"

- @DigiEngageNG

"No triangles. The client doesn't like triangles. We have to redesign."
"Who doesn't like triangles??"

- @ededown

"We have lost the client. Matters not, let rivals suffer the madness that is zero budget with maximum effort."

- @BradChuck

"Do clients even know the meaning of 'urgent'? Cos everything that is urgent never sees the light of day or is postponed."

- @staitfrmdgut

"One day I am going to dropkick the client."

- @CreativeBrummie

"Can you put it in-situ as unfortunately the client has no imagination."

- @Ad_Bitch_London

"It can be a small campaign. A campette."

- @WaytoblueUK

20.

ACCOUNTS

"Oh, I thought that the proof you sent over was the real thing so I already sent that over to the printer."

- @Alicat0303

"Does he look ABC1 enough?"

- @LiamLoanLack

"Ideally we would emphasise our point of difference but we don't have one."

- @Dr_Draper

Account Man to client: "Approve it or die."

- *@laumaree*

"What a nice deck you've got there."

- @Matty_J_B

"Have you got a spreadsheet that explains how all the spreadsheets work?"

- @KBallsays

"Creatives are like children."

- *@Charlottehugh1*

"It's okay, I brought my own highlighters."

- *@karenanita*

"I'm thinking a no-cost solution."

- *@LauraStanden*

"It's a bit ad-y."
"Funny that, because it's an ad."

- *@detlin808*

"Don't look at me like that. You signed up to lie when you joined advertising."

- @papa_action

"Are we actually having a slide in here with Scooby Doo on it?"

- @jo_bromilow

> "How scaleable is smell?"

- @AdamRoss7

> "Let's be as click-baity as we can be."

- @nicktuckwood

30.

MEETINGS

"HTML, CTA, ROI, WBS, BSR, QA, KPI. Sometimes it sounds like people are just saying random letters in meetings."

- @weareoriginalTO

"I attended this meeting for the free breakfast burrito."

- @JLuk

"Let's set up a meeting to talk about the meeting we're gonna have."

- @AgencyAddicts

"In future, please can you book this meeting for an hour and a half so that I'm mentally prepared?"

- @twietie88

**Person: "What's the meeting about?"
Me: "Someone's coming in to talk about something."**

- @ChaayaMistry

"Tissue meeting in the bathrooms."

- @CreativeBrummie

"Hi, I've declined as most of these meetings are a waste of time."

- @Kurt_Runge

"I survived another meeting that should have been an email."

- @go_rashi

"**Blamestorming - a meeting where you decide who was responsible for the f-up.**"

- @marionlow1

"**Shall we print the presentation... Makes it feel less formal.**"

- @michaeldwells

"I need you to dress really slutty for tomorrow's meeting. We CANNOT lose this account."

- @designByRamox

"No that was the pre-meeting to the pre-meeting of the meeting we're having tomorrow."

- @zoeperry_

BRIEFS

"Fuck the brief"

- @BOC_ATM

"In a nutshell, the brief is to polish the turd."

- @giulibrr

"A creative grenade = when you hear a briefing so you walk over, throw in an idea and walk off really quickly."

- @Jason_scott

"Just plagiarise the leaflet I've attached."

- @Libra_Comms

"It needs to be the same but different."

- *@CTolleyMusic*

"That's the brief – make it shitter."

- *@restreitinho*

"I'm already writing the re-brief, but go ahead and read this brief."

- *@BrandMonkeyKe*

"I haven't read the brief but I'm pretty sure it didn't say make a shit advert."

- *@StuuuCopywriter*

"The brief is there is no brief."

- *@AgencyQuotes*

"I don't know where you got that from.
It wasn't on the post-it I gave you."

- *@NicMunro3*

"Just because I put it in the brief doesn't mean I want it."

- @MelissaRaath

"I can't wait to get into your briefs."

- @courtneyprice_x

"Make it traditional and modern."

- *@markemoon*

"Don't you love it when "write the brief" gets added to your list of deliverables?"

- *@CristinaReyna*

"**Brief writing isn't one of his strong points, is it?**"

- *@PeterJStephen*

"**Let's discuss the brief in short, but not too briefly.**"

- *@rogueinkdubai*

48.

PLANNING

"What kind of timeframe are we looking at?"
"Yesterday."
"Right."

- @jessicagroganx

"Do this first, but before that do this."

- @rothbourne

"I've made some changes to the plan, but you won't have to do any work. Except for these rewrites."

- @CopyFountain

"I've got no red flags in my head."

- @mariethetwit

"Can we change the colour of the Irish media plan to green? It'll make it easier for me."

- @JackWinterr

"I've had to turn down a free weekend in St Tropez because I've run out of annual leave."

- @dimuthuj7

"Now watch me WIP."

- *@ArchieLyons*

**Planner: "I'm just gonna draw something up in PowerPoint."
Creative: *look of pure disgust***

- *@meas34*

"Which five jobs should I do first?"

- *@markmaking1995*

"Their end of play? Or our end of play?"

- @LukeBonner

"Sorry Trish, I know you've been working on this for a month but it's now cancelled."

- @DesburyHello

"We can't do anything without a job number."

- @AgencyQuotes

"That's not me panicking, that's how I am all the time."

- @fergasparin

56.

STRATEGY

"I've just visualised the shit out of my strategy."

- @ry4n21

"Our target audience is basically anyone aged 16+ with a mouth."

- @wbonnadio

"Creatively strategic; strategically forensic."

- @doramiltaru

"Where does emoji targeting sit in our strategy?"

- @_eltee

"We sell people."

- @jamesebrady

"Strategy deck and chill."

- @cwilmc

"Stacey's Mom doesn't have the brand recognition necessary to forego an SEO strategy."

- @lagringaeterna

"I like your strategy but can we redo everything?"

- @vpgregorio

"just used the term 'strategy funnel' and I'm now awash with shame."

- @StefF_LXXXVII

"We think the sausage scene will really resonate with the British audience."

- @1000heads

"Your demographic is childish professional."

- @AllisonNTurner

"What exactly is the Content Strategy document?"
"It's anything we want it to be."

- @lucidcontent

64.

BRAND

"We're not allowed to call the manifesto a manifesto."

- @MrAndyPowell

"That dog is not on brand."

- @hannah_huck

"If in doubt, go off brand."

- @JamesDawe3

"We can paint the smell of a brand."

- @NateHrpr

"There are 2 kinds of brand loyalists — those who consume them, & those in advertising."

- *@noopurvasuraj*

"Whack a brand-aid on it!"

- *@foundsignal*

"He wants the brand to embrace NeoNeo Classicism."

- @Faraz_Aghaei

"Who would be worth more as a brand? Mickey Mouse or R2D2?"

- @pumpkinheeed

70.

GUIDELINES

> "Call them brand guidelines? More like a list of how to tell the customer you have no idea what you're doing."

- @AgencyQuotes

> "I love it when a company's brand guidelines don't follow their own brand guidelines."

- @joebgwhite

"It says here in the guidelines I'm officially not allowed to touch their bits."

- @Hobbsie86

"Were these guidelines written by a hippo?"

- @AgencyQuotes

"I don't give a fuck what the brand guidelines say."

- @eddsmith

74.

STUDIO

"Send me the highest of the highest-res files"

- @harukateh

"Fuck advertising."

- @Kalamwali_Bai

"Today I wanted to dress like something really scary."
"Like an Account Exec?"

- @NoelDavila

"I have to leave early today at 5:30."

- @DDBChicago

"I don't want to have to pay $9 for a lederhosen vector."

- @instant_j9

"Yeah we can work on it whenever you want. Not right now but whenever after right now."

- @iamvandale

"If I had anything other than a Thinkbox award, I'd throw it at you."

- @GreyLondon

"They think they're the lead agency but we're really the lead agency."

- @bravenewmalden

CD: "Am I still a millennial?"

- @ClairHeavy

"No, the final version I shared is not final final. I'll send over the final final final version on Monday."

- @yishuwww

"I have an emergency black tie event to go to."

- @Wooldebeast

"100 million hits on a dog that can say 'I love you'. Why do we even bother?"

- @_ranners

"Blowjob issue sorted."

- @louisClement

"OK, it's 9:30 pm. I'm going home."
"Ooo half day?"

- @noopurvasuraj

On the phone to insurance:
"What's your role?"
"Creative Director."
"In what field?"
"Advertising."
"Anti-terrorism?"

- *@BOC_ATM*

84.

BRAINSTORMS

"We could have a nice good-looking button…"

- @jo_bromilow

"We just need some hot girls."

- @BOC_ATM

"I wonder if capes are a step too far?"

- @tomallwood

"We can't use Cheryl Cole but, y'know... someone the same."

- @denialvibes

"Don't write this down, this is just giving you a high level brain dump."

- @ChorusDigi

"Think about it and pretend the budget is infinite."

- *@livecontent*

"Do you have any hot friends? We'll pay them."

- @gypsy_jangle

"How hairy do you think the condom should be?"

- @AdamJackson26

"It almost feels too divorced from the product."

- @timtimo

"Maybe we should iconize it!"

- @TheSparkGroup

"A man French kissing a cash-cow is not a bad ad."

- @MasonWills

"Would you like me to keep it strictly to wizards, or shall I widen it out to include magicians?"

- @tomallwood

"Smells like brains in here!"

- @pmurraydesign

"I have the best sad face banana I could use!" "That's right, you do!"

- @AdeleMitchinson

"Can we force consumers to feel mindful?"

- @beccamagnus

PITCH

"If you don't have a bacon sandwich the morning of a pitch, is it really a pitch?"

- @MattSilverPR

"Has someone got the pitch playlist on their phone?"

- @DanAppleby1980

"At one point in that pitch, it felt like I rose out of my body and looked down on myself thinking how good I was."

- *@mcaulay*

"The client fell asleep whilst we were pitching."

- *@AgencyQuotes*

"Pitches be crazy."

- @Share_Creative

"How did you get the idea?"
"It's the same one we used for another client."

- @VikkiRossWrites

"Going home at 11 in the morning the next day after a pitch is my walk of shame."

- @Kalamwali_Bai

"Is there any food left from the pitch meeting?"

- @AgencyQuotes

98.

SHOOTS

"The dog looks a bit serious... can you make it smile?"

- @Magnafication

"We don't need a model, we have Photoshop."

- @cjdrox

"So, what you're saying is that the Pope is ruining our gingivitis music video shoot?"

- @AskMikeHopkins

"The cupcakes are for a shoot, can you please stop eating them."

- @followloop

"What's the point in being on set if you're not getting fat?"

- @KayliVee

"We'll handle that in post production."

- @bhatnaturally

"Can we make him look well behaved in the shoot?"

- @Cara_Bunce

104.

COPY

"Is the copy necessary?"

- @KayliVee

"Hey, you're good with puns, right?"

- @capngraphics

"I'm crowdsourcing straplines."

- @RobynHFrost

"Where's my tone of voice doc? I need to see the list of words I'm supposed to use again."

- @Acap42

"It's ECD copy. That's why the sentences are longer than a 70s pornstar's willy."

- @tiaanras1

"Start with a pun and work backwards."

- @Sidoniechaffer

**Copy: "Who wrote this?"
Account Manager: "Oh, I did it."
Copy: "Half day. AMs have clearly got this. Pub?"**

- @Acap42

"Let me lorem your ipsum."

- @ktlangers

"Just massage the line."

- *@AgencyQuotes*

"Shit me some keywords."

- *@karenanita*

110.

DESIGN

"You're not changing the world with this single banner ad."

- *@ilungaize*

"When I look at moodboards I've made, I just think... Wow, how am I so good at making moodboards?"

- *@ZachandHarriet*

**"It's getting too creative, and I don't want it to be too creative.
Let's do it in Excel."**

- *@kateryrie*

Creative: "So what's your role here then?"
Client: "I guess you could say I'm the Art Director.."
Suit: *face palm*

- *@tompeters22*

"Make them look more Canadian, he looks too British."

- *@heartofzinc*

"She's got a bit too much sideburn, so this ear had to go on this ear."

- @brodie_mk

AD: "I wanted to smell what they looked like."
AM: "I don't understand creative."

- @PaigeLauren2

"If they don't fit, just cut their feet off."

- @webdarren

"Can we make the buttons look more like buttons?"

- @jonstokes

"No panties... in the visual."

- @SarongJohnnie

"All this effort for something that's extremely vanilla."

- @singostokey

AD to CW: "We should just wear diapers, and pee on ourselves so we never have to get up."

- @CandiceMonster

"It won't win awards."

- @AgencyQuotes

"Do you want me to design it like this, or do you want me to make it look good?"

- *@Mededitor*

"It's getting there…"

- *@parallax*

118.

LOGO

"We don't need a logo. My nephew is designing one for us."

- @GraphicEddie

"How big is the font size on your logo?"
"Well it depends how big you want the logo."

- @Mac_Daddies

"No we don't have the original logo artwork. Can't you use this letterhead?"

- *@ChapFromStaffs*

"Why are you charging me for a text logo?"

- @ahmedsalims

Recruitment company feedback on logo concept: "It looks very recruitment, can we look less recruitment?"

- @JTHarrison92

"Make the logo spin."

- @Cilhaul

"I like it, just make the logo bigger."

- @racebarnics

"Can you make the logo either really wonky or not so wonky?"

- *@copytyper*

"We just need to wipe the slate clean and make it look like these logos."

- *@mdesignr22*

Client: "That's not my logo."
Me: "It's the one we always use."
Client: "No."
Client 5 mins later: "Ok, so you were right."

- @liamdixon

"I love receiving a logo in .doc format!!!"

- @Farrell_Thom

FONT

"Do we need Futura PT condensed extra bold, or Futura PT bold italic regular?"
"I literally don't give a shit."

- @doritosyndrome

"The client's asked if we can add dots to all the 'i's, as their font doesn't have them."

- @MrAndyPowell

"Oh god, someone's actually got an email signature written in Comic Sans!"

- @EMStreets

"He's a back seat kerner."

- @AntidoteLDN

"This font doesn't have apostrophes so I just left them out. Does it really matter?"

- @StuuuCopywriter

"Can we make the font more neutral?"

- *@ElevenBlackUK*

"If in doubt, use Helvetica."

- *@jamespentland*

DEADLINES

"Screw lunch, I'm on a deadline. I've got to search Shutterstock for the perfect picture of a brick wall!"

- @walshpjames

"The deadline is the deadline is the deadline. Unless the client moves it."

- @AgencyQuotes

"The deadlines will only end when we're dead."

- @theshwetamenon

"The print deadline is today. That's the problem."

- *@portishair*

"You have 12 hours to complete one week's work and it has to be delivered."

- *@jamespentland*

"So deadline is Thursday?" "Yes, so tell creative we need it by Monday."

- @Emlinq_AD

138.

TIMESHEETS

"Your timesheets are outstanding." "Thanks."

- @BOC_ATM

"It says on your timesheet that you worked 76 hours last week." "Yep."

- @OneMinuteBriefs

"Best thing about being ECD? You don't have to do your own timesheets any more."

- *@FullFatEdam*

"What's the timesheet code for fuck loads of feedback rounds?"

- *@AgencyQuotes*

"I just found out you can put emojis in timesheets."

- *@CandiceMonster*

FEEDBACK

"Can you turn it into a PowerPoint?"

- @stephenhunter21

"Can we have more ball hair, please?"

- @clairestrickett

"We love it but can you turn the sunnyness down?"

- *@Datt_Meegan*

"Take this picture and place a hashtag on it to make it look like a marketing campaign."

- *@silkefuenmayor*

"Can you please Photoshopically add meat to this stew?"

- @pishonboboye

"Don't rotate it clockwise, rotate it anti-clockwise all the way to 360 degrees."

- @ashshanuferns

"Can you make the chicken more... chickeny?"

- @hobbittfeet

"The crumbs need to be defined more."

- @galoobzzz

"Can we make it less contenty and more TV-y?"

- @ConnorJStephen

"That frame's left side is very empty, can we crop it out?"
"Yeah lets cut the TV in half."

- *@ankitdoshi*

"It needs to be more generic."

- *@CopywriterStu*

"The designs are great but they are all square. Can we do a round one?"

- *@michaeldwells*

"So yeh, can't be more than 20% copy and it needs to be on a long square."
"So on a rectangle?"

- @atAlexGoddard

"It's the amount of cheese that's the problem."

- *@LewisEdinburgh*

"They love the concept but want us to change the strategy and execution by tomorrow morning."

- *@racebarnics*

"That looks great, but I found this awesome design on Pinterest. Can you do it like that instead?"

- @Ewen_J_Milne

"Replace the pigs with the monkey."

- @dognbonesjones

"The client wants to make the ice cubes look less ice cubey."

- @tompeters22

DATA

"We torture the data until it tells the truth."

- @jennyheinrich

"You can tell it's Friday when the "Yo data's so big..." jokes come out."

- @McGuireDavid

"What's your data point on beer?"

- @SarongJohnnie

"Big data isn't enough. It's time for Massive Data."

- @mattpooley

"We're just looking at the data now and then we'll visualise it."

- @AgencyQuotes

SOCIAL

"Can you make it more viral?"

- @welchwords

"We need you to make tweets to promote this video, but we can't show you the video because it's confidential."

- @FranciscFeijoo

"What can we use as a hashword?"

- @denialvibes

"How many followers does your cat have on Instagram?"

- @BareCollective

"Client wants to know if we think their hashtag has become too passive?"

- *@allviewsmyown*

"Six shares? It's not really gone viral, has it?"

- *@AgencyQuotes*

"Isn't boosting content on Facebook cheating?" "No I think they call it advertising and marketing."

- @SarahJLBeane

"The horses don't have Twitter handles?"

- @kirstycarrot

DIGITAL

"What size is a website?"

- *@AgencyQuotes*

"The only sites that are blocked in this (digital) agency are other digital agencies."

- *@sharoncaddie*

"Googlize it."

- *@mcaulay*

"Will sing for click through rates."

- *@kgdecruz*

"Mobile browsers are more promiscuous..."

- *@HattieAhmet*

"Can you send me the square image?"
"You mean the MPU?"
"Oh! *shocked* That's what that is!"

- @OMGitsRLR

"Please print out how the website will appear on screen."

- @oneowlplease

168.

CHRISTMAS

"Christmas just needs to be put to bed."

- *@Luda_M88*

"How do you make a reindeer look disgruntled?"

- *@atAlexGoddard*

[Planning a Xmas ad - two AEs stare at a sunny pic]
AE1: "Can we just add some snow?"
AE2: "That could work..."

- @incognitoCreate

"Does this fig look figgy enough for you?"

- @VerityWheatley

"Fuck Christmas, we need to start talking Spring."

- *@WonderOfAWeazel*

"They do know that Christmas has actually got a deadline?"

- @re_scrawl

"Could you zip all of the elves up in 1 folder please?"

- @BOC_ATM

"All I really want for Christmas is good penetration, and I'm really counting on you to deliver."

- @liamdixon

"Put some holly on it so it looks like Christmas."

- @webdarren

"Can we push back on Christmas, or is it a fixed deadline?"

- @arminthedoor

"Ellie, you're good with Photoshop, can you make this turkey look cooked?"

- @EloiseGarrett

"Christmas is approved."

- @ABlakeley

"Can you do it again, only better?"

Yes, the fun doesn't stop here...
Head to @AgencyQuotes to tell us more
#thingsyouhearinagencies and you might
just feature in our next book.
Thanks for reading.

www.ingramcontent.com/pod-product-compliance
Lightning Source LLC
Chambersburg PA
CBHW070229180526
45158CB00001BA/273